FEVER AND BONE

CAROL ALEXANDER

DOS MADRES

2021

DOS MADRES PRESS INC.

P.O. Box 294, Loveland, Ohio 45140
www.dosmadres.com editor@dosmadres.com

Dos Madres is dedicated to the belief that the small press is essential to the vitality of contemporary literature as a carrier of the new voice, as well as the older, sometimes forgotten voices of the past. And in an ever more virtual world, to the creation of fine books pleasing to the eye and hand.

Dos Madres is named in honor of Vera Murphy and Libbie Hughes, the "Dos Madres" whose contributions have made this press possible.

Dos Madres Press, Inc. is an Ohio Not For Profit Corporation and a 501 (c) (3) qualified public charity. Contributions are tax deductible.

Executive Editor: Robert J. Murphy

Illustration & Book Design: Elizabeth H. Murphy
www.illusionstudios.net

Typeset in Adobe Garamond Pro
ISBN 978-1-953252-17-3
Library of Congress Control Number: 2020950565

ACKNOWLEDGEMENTS

"Agape," "The Idea of Valley," "Pacemaker" – *The Hamilton Stone Review*, 2020.

"Although, Etc." – published in *Belletrist*, 2018.

"An Anthropology" – published in *Rise Up Review*, 2019.

"At the Buddhist Temple" and "The Reading Room" – published in *Sweet Tree Review*, 2019.

"Autumn" – published in *Poetrybay*, 2019.

"Cold Spring by Train" – published in *Home Planet News Online*, 2018.

"Dear Vagabond" – published in *Stonecoast Review*, 2019.

"Dissonance" – published in *One*, 2018.

"Fever Palm" – published in *The Goose,* 2020.

"First Drunk" – published in the anthology *Last Call*, World Enough Writers, 2018.

"First Field with Subject" – published in *Denver Quarterly*, 2020.

"For the Dark" – published in *The New Verse News*, 2018.

"Generation" – published in *Aji*, 2020.

"Gratitude Rock" – published in the anthology *Waters Deep*, Split Rock Press, 2018.

"I Almost Loved This" – published in *Postcard Poems*, 2018.

"Immortality" – published in *The Healing Muse,* 2018.

"Immunity" – published in the *Long Islander*, 2020.

"Interactions" – published in *South Florida Poetry Journal*, 2019.

"In New York, the Spring" – published in *The American Journal of Poetry*, 2020.

"Lonelier Planet" – published in *The Avocet*, 2018.

"Politics" – published in *Poetrybay*, 2020.

"Save Time by Night Services" – published in *Home Planet News Online*, 2020.

"Social Distancing" – *Pangyrus*, 2021.

"The Cyclist" – *Pif* Magazine, 2020.

"Torah, Paint, and Obscurities of Desire" – published in *Halfway Down the Stairs*, 2018.

"Meat" and "What I'll Miss" – published in *Bluestem*, 2018.
"Solve for *X*" – COVID Lit, 2020.
"Stone Fruit" – published in *Literary Mama,* 2019.
"The Climber on the Bells" – published in *Cumberland River Review*, 2018.
"The Firs at the Lake Cottage" – published in *Avocet*, 2016.
"Thieves" – published in the *Raintown Review*, 2021.
"Virus" – earlier version published in *The Seattle Review of Books*.com, 2020.

for Ned

TABLE OF CONTENTS

FIRST FIELD WITH SUBJECT

The past was object, what could be seen
from the gate that surrounded a farm

past the creek's sister gully. Nuptial, whiffy
where rain sluiced spawn and the rot clung.

Subject to urgent adaptations of cloth and bone
in the hummocky drifts of grass,

flesh that is flower and also mulch,
root fingers scrabbling—

he, boy with the roan horse,
unbridled, half-broke.

A mouthful of spring, artifact and eye;
why must a body reassemble itself.

How does a tongue probe a far field
inside a mouth that hungers for dirt

as a quick belly craves
what's familiar, say sphagnum, though strange.

What could nourish such a one
ascending at last to the perpendicular.

Earth so thirsty with your variegate crop,
bend moan to meaning. Field, foreground us.

THE CLIMBER ON THE BELLS

Tap the mudstone cliffs, their banded bones.
Tongue a drift starry as the valley's columbine.
Spidering down to five thousand feet, see
how a beaver slaps the river's skin in wild applause,
its structure a seeming error or mischance,
a child's bedaubed mud castle, detritus of the storm.
Or a Calder mobile, the precarious off-centering
a vertiginous flight plan. Jetsam swirls downstream,
current so quick and hungry, a pitiless blue.
There's the irritable plash where a bird's egg lands,
the tourney of open jaws: a fox gullets it down.
Everywhere, the continuum of industry is hit or miss
the way a frowsty nest may judder in the wind,
the way the rope inflicts a sinister burn.
When the body on a slipshod ledge suspends
a stellar instant, kicks out blind, and falls.

GRATITUDE ROCK

Faint grooves like frozen waves, what washed
from great Superior at the midpoint, far from the salt flats
of the east. Insular coast. I was learning its body,
and the jagged cliffs nesting at dark.
My horse was for distraction because there was no sea.
Gratitude rock, token of luck—agate to conjure the ocean
at night, its fog and claws,
yet planting us in the flatland heat.
The horse has foaled fleet decades though I cannot
chase them down, the suns and moons of Michigan,
the quarries where I breast-stroked, bare,
against a muddy trespass sign, the swamp
where I first saw the little heron winkling fish at dusk
in its sodden opera cloak, dagger quick at deadly work.
Gloom of afternoon, pink veins tracing a watery pulse—
rock does not replace itself or replicate like animal cells.
The cells will die, but the rock I take between the teeth.

HAPTIC EXHIBIT

Darkness being arousal's first stage, we desire.
Fluttering gloves tease neural pathways,
shadowy percept mapped by a velvet rope.

The sightless crowd crocodiles
where a Manet lemon dominates an earthenware plate.

Maybe the poem's wrong to insist.
I know what we shared —a blind woman teaching me
lunar coolness, the tight little knot, sourness.

When she takes off a glove the sensation remains,
a thumbnail peeling back skin from orotund fruit,
light beaming through the skull, into a haptic past

and later I look for anything lemon,
for a Lisbon cultivar nipped from twigs before a frost

while the pickers keel on their high ladders
in an electrical storm of nerves, the Sun a loupe
finding flaws in this late crop.

THE IDEA OF VALLEY

Laid half-bare, by winter disarmed,
translucence of shirred pond ice.
With necks like the handles of amphorae,
a crushed velvet shine, geese churning urgency,
hardscrabble creatures un-compassed, elapse: pass by.
Want and disbelief, the knocking at hollow trees—
today this city far from a yellow valley abandoned more.

Mooning trucks roll by; rain, the intensifier,
most green, saturates beneath a wave of itself
while a patch of weed bleeds tawny
in the sluice of old snow. A delta of found things,
a vernacular of sweet and rust.

And beyond the horse guard hardens to bronze, season of patina
where the reservoir divides from blackened muck;
the alluvial impulse of this land backing up,
fistfuls of silt, suckers bleeding flesh, bodies made to disappear.
See the bloat of floating scum, hands clasped.

Remember the elementary stroke, breast to ellipse,
lifting you over the river's skin, and how a valley rustles
in the long growing season. How it stays yellow and stays.

AGAPE

You had a dousing stick knobbed with a mantis head
to find a wallow thick in nascent spring
streaky with beginnings, piqued by the sun's swarm,
a crush of pulpy twigs, rotten veins.

The gilled originals of newt and frog in slime
fed there in mossy, lung-less forms, shivery and vague
in the demotic pond.
Light phased them into gold
though what they were in themselves, you didn't know.
Maybe monsters or harbingers.
Rainbows trailed the hushpuppies, broke over jagged rock.

Who grows nothing from its source contemplates
nothingness, filches from a hedge a bird's egg drab as dirt,
you've the morals of a fox, taking things
unexacting and defenseless as the simplest nouns,
shapes akin to fish pearls in this quenchless mud.

A confusion of magic and mystery—
Prospero breaking his stick.
When it seems impossible to love the world enough as it is
and will be, you think of transformations everywhere—
that good relentlessness, a myriad opening mouths.

FIRST DRUNK

Drunk is a field ridged with stones that hummock up crude,
and you are sixteen, stumbling in divots incised by hooves.
Drunk is the boy's leather coat, lax where it hung on a peg
for years, coat of the father who needs it no more.
Thirst that grows where it should be slaked,
snow muffling the tongue: only to bloom again
in the bottle, the coiled worm so cold.
First drunk, the stars split and crumble,
carve out a sickle face. This spectral ground, void of life—
where are the crows, the silky mice?
They're webbed in branches, or under the earth;
a leached sky quivers to the thrum and his mouth,
like a horse's, tastes faintly of apples.
His mouth like a horse's is soft to the bit, long bones
shudder for the crop, tequila's blue burn, muddy embrace.
And night is a barn fragrant with oils, heat of the mares,
lonely moon that peers through his eyes in a silver draught.

STONE FRUIT

Mother braved the ward with a bag of plums
while you ran to ground like a hunted fox.
Blood pulsed in dark flanks over far fields,
a mess of costive roots, the sky sweating salty rain.
I could eat no plum, nor any stone fruit.
Mother ballyhooed the hunt,
wiping the wetness from her chin.
I marveled at the pain's rigor,
the chase after a wild, terrified thing
and yielded up a tender pit,
a torn cry, fugacious love.
For years I'd feel the afterbirth
squeezed from my flesh, warm plum juice.

LIKE WILDFIRE

What grows best around the San Lorenzo,
what names of rotten root, of fish scales.
Sky a strained gauze after amputation—
storefronts turn their backs
on the river's unkempt fringe
where smoke weeps over the dam, teases out sediment
left by the powder works firing lurid clouds.
From the trellis where bees drop blackened,
daylight is compacted to a flint
striking out rusty sparks, just the rumor of wet
from the headlands while these acres wait
so acrid, streaked by a martyred red.

SOCIAL DISTANCING

When social distancing, how far:
the mirage of others, ombre of their vanishing points

like—and only *like*—a hem stained dark, dementing
the spectrum with evanescent egg wash, cockleburs.

Born into mistrust, breath's a crisis of proportionate air.

Love's poles shift as the bar goes dark.
By the bins, rabbits feed,
hop neat through the mobile greensward.

There's iron at the planet's heart to magnetize
more than mineral—
the over-under of six feet.

I must touch you. I can't until the air unmasks.
Windows shine their blued elsewhere.

IN NEW YORK, THE SPRING

It was worse when cherry trees flirted a snub of pink,
the wards surfeited on something medieval, unforeseen—
the sick growing sicker until no breath pined for an ear.

Mass graves that haven the faceless
ad infinitum: when one passes, they are called poor.
The rest take offense. Such a thin-skinned tribe

under diamond scales, balconies where grow
miniature kumquats and peppers, the rain a devil's tears.

We go roseate or pale, singed salamander, cold fish.
Break water glasses with abandon. *It's a blessing not to see*

 white refrigerator trucks
 severed heads of the official mourners on TV
 unspeakable numbers traced in char.

And the clothesline of limp surgical masks
sunning on a threshold of another day,
Mondays and Fridays past,
how we gowned each other with the doctors and priests
yet when fever came straight for the bone
there was no surprise, just the flash of a bayonet.

BURN

What we have learned here
when even convicts shackled to the flames have flown
even roots with taut half-centuries of talk
are breaking stone

the united states of fire
is/are kindling

when I was a child I thought as a lake

while you in a caravan of paper & oils with accordion
hair still sleeked from the chlorinated pool
expel a plume from your lungs

wings of smoke rushing terrified that nothing
can stop because fire slew the children tugging at its dress
orphans caught in brambles of brush

who tore with small fingers orange tipped
& even the peninsula where smoke meets cold
kneels when lightning passes overhead

MASQUE

Within these interstices, birds of land and sea
fall separate through a hole in the northern hemisphere,
midnight in charred silk turning pettishly toward dawn.
Sleeves brush in narrow streets, eyes glistening apology:
see how I slip inside a shadow, full of words, fugitive.
Lights tremble behind blinds, a hectic pox party;
stories told to glasses of vinegary grape, nobody listening.
Bodies slick with sweat after love's morphine
rinse empty and alone, rise to change the linens
so touch will leave no secret cell.

AT THE BUDDHIST TEMPLE

A girl absorbs the rituals of loss.
In a storefront temple 6,869 miles
from Kyoto where her father's father drew a name on white,
she weeps dry ice, crystals faceting her cheeks.

She's learned the origami articulation of fingers,
kitchen pidgin, kanji ideograms in a drawer,
pollock spread on the butcher block.
Only here is rupture— a broken set of red dishes for a boy,
a torn photograph of a little sword. The girl starts to bleed.

Here is giving up. All but the syllables themselves
and night slouching over Brooklyn, and the temple bells.

Tomorrow he will depart as smoke in his skin of eel
and chopsticks will tease his bones from ash.
There's more than lacquered sky and furred smoke to parse.
Say, a bead of water on a knife cleaving mounds of rice.

THE READING ROOM

For you who are always here in the monastic archive—
desks initialed by the storm-tossed,
shelves of defunct presses stained with gilt and coffee spill.
With perspiration of a lost Dead Sea.

The window, glittering with variegated lusts.
Magnolia spreading flesh against the mullioned glass
while the Swedish and Ethiopian boys cradle their heads,
rowing spasmodically via unconsciousness.

To read is to be hungry and filled
with the stone lions gorged on nightingales. To contract
in northern cold and crack like ice in a sink

that mushroomed into the miniscule bedroom;
hours of abstinence were supplanted by a fanged desire.

Keats wanders through the verse section
luring students to his narrow, glittering gloom,
a gloaming of oranges and burnt.
Forever, he is nearly twenty-five.

Look urns where cigarette butts are quashed.
Look thumbprint of a girl in a long black sweater
asking simply not to dream of the fated one
on Saint Agnes Eve. Look: your vacant, watchful chair.

TORAH, PAINT, & OBSCURITIES OF DESIRE

They are parsing and drowsing
in the temple dusk, flies overwintering
in a bema of wood. Theirs is the patience
of crossword puzzlers. This morning,
one turned my hat straight-ways, cut the eyes
from blackened spuds. I'd been reading
Greek myth and lapping up spittle
of angry Hera, picturing virginal blood,
victims of Olympian rape.
This superiority of the chosen flesh—
girls who call down priapic gods.
Spangled in their beauty. Running hands
over knobby knees and pancake chest,
well out of the mirror's sight.
Brushing teeth, picking mold from furred violets,
I commit such multiple heresies, investing
all that I touch with a ten-penny soul. So bitter
to be told what can't possess a soul.

 & & &

The merchants of beauty are in love with Susanna;
her flesh has the sheen of an ousel preening.
Their robes balloon from the shock of her breasts
and though they are dreary, they bear desire
in its maggoty skin, knowing more
than Susanna, each clever as an egg in his wickedness.
The elders pun, naming the apocryphal trysting tree;
their teeth chew mastic and churn out lies.
And in truth, there are certain limits to the theme.

 & & &

The ink on the river girl is barely dry.
She wrings damp tropes from silken robes,
lulled by the temple's little brass bells.
She is blissfully left alone. Golden carp flitter in the pool.
Every day I see her and she smiles at me, a balm on desire;
I recognize that this is peace. Her soul if a soul
is the palest jade of seven soughing willow leaves.
Limbs lightly sketched, eyes less lucid than the carp's.
The river merchant loves her, a frail hand grasps at smoke.

PRIMAL SCENE

Piqued by migraine floaters, the storm
filches Cyclops' eye for eye,

sideways optics of wind and wet smirched by silt
in mad fistfuls. Transistor radios whine,

jealous silence dwindling inside dark lulls.
A scrape of fingernails on the fogged window spells twig.

From the flood plain view, a beautiful struggle building—
tumescent breakers, furious swelled heads,

bitter winds beating the waves to thin verdigris,
ecstatic architecture where the bay's salt forms a carapace

on mussel litter, the teasing beach plum smashed except
where a low branch shields the sweating globes.

Watchers at the estuary unpick peninsular veils,
ratty knots. Gulls gun for some cold meridian.

CATHEXIS

On a Saturday morning in the cavernous city,
 rain abseils down. An ash tree's grown so near,
insects are bared to their most minute extrusions
as they bore holes, cell by papery cell.

A certain lack of bodily intactness, an antibody—
touch becomes the surprised province of the eye.

Why open to the ash in such intimate contact,
searching tendrils moist as breath
the pressure on brick facade murderous as ivy,
branches thrusting between stories, an object become

a fixed idea, the force of old libido proliferating,
a creeping wet—the primal thing's now free to finger
what it long has craved.

FEVER PALM

A fever palm is an ancient reckoning
for bud of abscess and trembling fit. In desert that was blue
lie skeins of a broken lifeline.

Candy-colored water jugs tease the tongue with emptiness.
Fins that Helios charred litter the southern strand.

How quickly the skin burns, how livid the scars.
There has always been thirst. Then there is a thirst
that susurrates always: a dry wadi, seed grasses withering.

Come from fire into a cavern dripping moon milk,
fantastic underworld of a limestone karst.

Once was an ocean of ponderous breadth,
midnight a silk shroud against the Inquisition's squint:
so many epochs to learn a single, shining world.

And the wine-dark sea of gods rowing to tragic victory,
the page wrinkling in a summer rain—
we've lain in graves myth-made
borrowing names against the whirling elements,

have crawled over rock face mapping composite
and licking our own sweat, mouthing facts at the wind.

How to live as heat's confederates, cattle seeking pasturage
beyond the steel fences. We'll be beautiful
horned skeletons.

Or we will live.

How small, says the noontime shadow, tail flickering.

SAGE BURNING

A mower labors over streaky winter clouds.
The heart is a fruit slowly ripening for another's grasp.

A body tires of giving, of the mind's rebuke.

In the fields, musk and silver mantle a reek of matted fur.
Lacking stewardship there is steadily less.

I singe a sooty stick, open a window up to night.
Your temperature has gone rogue; sweat dries to a sly flush.

Old houses had deep airing closets.
If ghosts were embarrassed by their rot

they were given beeswax and herbs,
spiced drops of vinegar.

Did I think or say, *The body gathers itself like a harvest.*

Once they cut the tongues of liars, of truth-tellers—
a snip, a gush.

THE CYCLIST

Body—its cloudy streams, fat and muscle cells,
electricity pinging taut membranes. An egg
pricked at mid-cycle, sweat glands marbling the skin,
everything working ingeniously.

The cyclist flies over the handlebars in an impossible arc.
We ring around the brink of breath, there's no helmet,
imagine a chalk outline, drying flowers.
If motion, how imperceptible—

tiny hammers striking in the red chamber,
in the wristlet of veins, wind combing hair stiffened with ice.
Through the vestiges of ruin, we see
that she is unspeakably young.

Blood garlands the fragile skull, hematoma in cold aspic,
blood having a type cross-matched with leaf-strewn soil.
The untethered bike lies forlorn, an exhausted horse
that stumbled in the wet.

Can we share out suffering, the smashup of creation,
fix this human machine, touch what can't be touched,
sympathetic pulse, blur of images under eyelids,
each limb still responsive, barely,
to the sun of consciousness.

How to penetrate autumn's fullness down
to the rumoring roots,

burial of so much, a waste-weed mulch.
Some of us will wander far from
tangled wires, fluorescent vigilance,
the excruciating return to self.

IN THE SCARECROW VILLAGE

A breeze corrupts the tang of cherry and plum,
a needle stitches refugees from discards
in a census of the moribund, an art of impossible things.

Puppets sway neither towards nor away, all busyness done.
Around the village weeds grow up
shedding wickedness, simple and pure.
No one whispers here.

Teacher and farmer swing side by side,
a calligraphic monk condemning crows
who pluck at his eyes.

Here the crocus has preceded, all purples and yellows,
color where there is no scent. High-speed trains go by

where the puppets cut from a greasy wedding quilt
find a second life. The tailor recalls each seam of a face.

What are prayers but drops of blood?
What is the point of making these things, an end in itself?
Suffering is stirred by the wind. Listen, crooked ears,
citizens of formerly.

HOLLOW

The pond's double-glazed monocle
reprises its own glance.

Around aboriginal graves,
weeds press through the spokes of wheels;

for a geological hour, the valley was immune—
tufts of white and red waving under dark wings.

I think this is the umbilicus of the land
or one anyway

and the pond baptismal,
its fontanel sinking steadily toward drought.

KNOWLEDGE

A soft variant of vigil goes on
in the TV room where children unwrap candy
to suck on inquietude, foretaste of loss.

I partner her in breathing,
the ragged silences, thin aspirated doom.

Little pouches of time from the black market—
I've emptied my pockets of rye and rue
for birds to peck in the parking-lot.

The insular body tongues an arid grief,
strain of some eternal stuff. I was born to hear,
to memorize these broken lines.

A *psalm* sounds of the sea.
Through what forms do I pray in this harsh light,
or is it to the light itself
picking out the marionette's wires.

Limp lettuce, day-old bread. A guilty meal for Judas self.
A new planet comes about, ringed and trembling.

DEAR VAGABOND

Delicate as gristle, as inky black jade,
a calligrapher feathered you one wet midnight.
In your brief struggle with a tadpole, stab of wings
an unexpected white aft, fading into soft charcoal.
The skiff bears a clutch of eggs through this cold backwater,
this necessary nowhere. I came to feed the nursery ducks,
waded in the weeds to photograph a nest but drew back
at the curious feet kicking cruelly, the female's shrill *ai ai*.
Today the marsh has a hearty stink: sewage is flowing east
and the oil of a motorboat; I'll never be innocent again.
Dear coot with your fan of twigs, your sedge grass frieze,
this hard rain slumping a beard of leaves, a fatal pool.
Stowaway, may your bulrush babies grow tough,
common as mud freshets, battle on and brood.

PACEMAKER

The brain is meant to give in last.
Mad buccaneer, you will run aground and let us weep.

Around a tactful corner, evening staff keeps the log.
Drivers smoke on the graveled path
that leads to the convent deer park

and within ashcans, blackened troughs
of day-old food, crows camouflage.

A corpus lies shrunken and remote,
wouldn't wish to be displayed so baldly
for all the chant and incense
though Pascal's Night of Fire would please the nuns.

All else outlasts— stained cotton sheets tucked shroud-like,
canned symphony of a radio, a thrum
that is the pattern of electrodes
but what is the intransitive warmth of a sense memory?
She recedes into a sea of ice.

Underground, rootless rhizomes
sprout from an array of organs;
it's still summer with its frail archaeology of light
and citrus scent and ruins.

Will death weigh so little at the end—
water has no shadow, only a directional, glancing shift.

SAVE TIME BY NIGHT SERVICES

—painting by Kenneth Shoesmith, c. 1930s

Shoesmith was *content* year after year
to serve Her Majesty's dominions
in steamers of the Royal Mail via silken ropes of Empire—

from Kingston & Holyhead through tropic bilge
to lush port cities of the South.
Came queened & franked the self-important post.
Looking-glass portals & stout bulwarks:

the Sun never set as yet — there's a Union Jack
over spools of cotton, canisters of Ceylon tea
(uplands very suited to the uses of cultivation)

Shoesmith limning trenches in an opaque ocean,
winches hauling salt shadows,
great engines throbbing, hull smeared with feathers & blood

while as ship's officer he sips tea in a caul of fog unfazed,
having engineered said fog to test the masthead lights.

Round the fore & aft he circumambulates
(the crew would know his painted ships if Davy Jonesed
or steered by Shoesmith to a permanent dry dock.)

But his *Night Services* ("in time for a day's business")
the wings of some frantic thing furling from the smokestack

a second ship from Southampton racing along flirtatiously,
blue whale saving time on Britannia's waves—

what can we know of Shoesmith
& his youthful romance with the deep,
wild birds of the littoral & gold ships transecting
the swell, the plural uses of art
perhaps to make the sea clangor alarms.

COMMONPLACE BOOK

Whatever I tell you slipped naively in
to vie with the acid bluing of hydrangeas —
but is this aggregate pure self-defense,
acres of years behind me, a name that changed to joy
then found its home among small stones.

Simply because one remembers
a thing becomes animate on the screen.
Something acceded to without
even knowing the matter of it.

See how skin sheds fertile dust.
Pollens sift down from clustered twigs that suspend forms,
winged bodies impressing some future part.
A universe of discourse.

I will close one day upon this self-knowledge so hard-won
as a chrysalis fancies itself the ultimate stage,
mistaken for a horn shell far from the sea—
brambled, cognate, spun about by wind,

easy to confuse with artefact, this stage of making
which requires the full spectrum of imaginal to
differentiated cells.

And how hyposmocoma and hydrangea
thrusting up monster waves also disturb a far atoll;

I record this without a flick of the yellow pencil, tricked
by the vividness of memory, that briefly habitable shell.

PASTORAL

Shepherds drive pickups on fogged back roads,
a tree trunk at a crossroads marked with gore.
I came for the shimmer of moon in a lake,
black-watch loons. Death has garrisoned the town;
even those strips of sidewalk fenced by metal bars
seem fragile as the ground glass lungs of aftermath.
Humans eat alone, distrusting their own meat.

The shrike's nest struck by lightening filigrees a pine.
No flesh or tiny bones for hands to sift or calibrate.
In the darkness overhead, the female sharpening her lust
draws me into whatever a mosquito is—
and the baseball bat by the nightstand,
the serrated kitchen knife in shining readiness,
a mirror poised to catch the foe with a face and fists.

DISSONANCE

Afternoons, Grandfather patronized a café,
outpost of *Amerikadeustscher Volksbund.*
Linzer torte mit schlag. Depression glass,
those powdery crumbs snow melt.
The pastries were baked in encryption;
he fed himself broken bits of code.
But why did he spy on the enemy?
Some find ways of confounding death;
thus Grandfather, who'd gambled for tickets
to *Parsifal.* He later bought a ticket
for a stinking hold, weevily brown bread.

At dusk he passed a palm through flame.

Gedenken und Frienden. Day's end brings peace.
He still desired the wife in France,
a six-month child, a cousin's mislaid bones.
The bones had felt at one with their land
and now they were, with ashy rubble
for a makeshift headstone. Grandfather ate cake
with gloved fingers, wiping cream from his beard.
No place for Mezonot, the blessing on five grains.
His suit, I think, would have fit a larger man.
The cousin's bones were wrapped up snug
in chimney smoke and the holies of Siddur.

BREAKING SILENCE

Ice cracks. Ships carve crystal burrows
in imitation of Arctic fox. The dome trembles,
then nobody sleeps in a circle of white fire.
Stars migrate after the moon.

As tramp steamers pass, sucking up sea,
spring blossoms from snow.
Funny how we know shapes we cannot logic out.
How else do children script such nightmares
out of simple archetypes?

The nursery wallpaper: a half-thawed mastodon,
a giant thermometer rising plus one. The sun
melting a mountain of glass, the heliocentric bow of light.

We have many debts and mark the cycles dutifully.
Not quite nature, the street obscured with blackout shades;
we learn sleepwalking by the porcelain glow of eyes.

My dear asks for a fairytale.

> *Cold kept them keen with awl and knife.*
> *The reindeer legend was grace on delicate hooves.*
> *Then the young began to suicide.*

Names we've yet to learn are buried in mortar and mud.
Houses draw together, biting their lips.

AMBER

How the eye bypasses the perimeter
to spy out wheeling Sun before it slips into the valley's palm

slightly sticky with the tree sap
I'd find frozen in winter's beads, a stuff once viscous

smothering the feathery longlegs
(paused so fatally to feed.)

Crawls an ant, jaws clenched around a bolus,
another sort of bead. And into the slippery, seductive gum.

When you come here with your thirst, still life flares
in its mineral way, potent without agency;

when you dig up amber, a root of unctuous sweat,
when pieces of the Sun grow searing in your palm

even that blood-orange star, viewed from the tilting ground,
seems somehow liquefied, tender at the aphelion.

AFTER THE LAST PANDEMIC

a dry hive was dead-out
melt was sugaring time
to open the frail leaves
after the scent of capped honey
a mammal left its wormy scat
artefact of badger slow with milk
in blackberry-studded crabgrass
the sun dips into a small wallow
when bees tenant derelict nests
inclusion/ reciprocity/
the coded waggle dance

AN ANTHROPOLOGY

The story is the king and the people who loved him
so to run through the vines of yam weeping for his death
a hundred years ago. They stumble over hummocks
with whitened eyes—it begins and ends this way,
whenever the lush thicket's breached.

Death grasps the ankles, sucks out breath.

Anthropology 101 boards the Cincinnati bus.
The girl from the East, too city
for Ohio's livestock pens, thinks *Cincinnatus.*
If myth, so be it, plowman or warrior.
How glad his wife and children binding sheaves
glow at his cheerful, ragged return.

Is that you already? Where would the emphasis be—
it depends, of course, on the wife.
She probably can't imagine a mercenary fighting
just for Juno's money because war bloats and battens
on the fat and gristle of ideas.

What is jail? A *very* rough idea. All is relative
now the king has died again.
Whether the convicts want to spit at them
who knows, the visit has forced the scouring of commodes,
the slicking back of stubbly scalps.

You there girl, what I'd like...

Must never commit a crime, then. Anyone can.
In dreams you cross a line
and cower for your apt punishment.
The patricide is smoking in the yard,
clanking his invisible chains.

All the marooned mariners with farsighted eyes
are swimming toward the sun in search of a new king.

AT THE BRIDGE

Pigeons helicopter through the smashed transom.
They skid around a kiosk, scavenge vending machines,
disrupt games of dominoes.

Spring creeps over the melting bridge,
leaf veil floating down the Palisades, the guano-snowed cliffs.
How cold April is.

They are so much lovelier, *Columba livia*, singularly,
ivories and grays that pout their lust in sudden violet or teal.
Their wings fan out against the cornices in muted traceries

flying above insult, our poisonous campaigns.
They have their infidelities, widowhood cocks
 in drunken flight after a racing spree
while the hens cling to stone, to brittle nests.

Once, April deaths were few.
All winter the birds that bathed in slush
strung themselves along power lines,
sensing the shock before it came.

I recognize by stippled necks, missing toes,
these common watchers at the bridge
above the river cruel and sweet,
some force relentless in its thrum.

THIEVES

Thieves have eaten the lily flowers.
This is a thing you can't remedy.
Hummocks the color of lead, you remember
jet beads and chicken with cinnamon

O family side-by-side, brunette and blond,
louche and abstinent.
Let her paint yet come to this. Heels sink into shining clods,
and it's strange how children put dirt to their lips,
squeeze the eyelids shut, then bite;
the gravedigger's skin is the orange of cedar wood.
You want to appease him, tip the scale that weighs a soul.

Are you a thief?
If the good die young, you want to be wicked,
or at least a tree of succulent heart
with branches that only seem to yearn.
An invisible owl spits out stones.

Why does everyone die in summer, under a tender sky?
The herd of cars, docile in the narrow lanes.
Such odd pasturage where horses,
spangled and apple-sweet, once strayed.

WHAT I'LL MISS

The curvature of your hand,
pen gripped before a pile of bills.
Long silences, then a spate of water from the tap,
a pan of boiling beans. When I'm not here: but time will cure
this deep desire for everlasting cold, this moon-like wound.
The photographs of lost dogs, teasel rough—
none outlasted your patience in picking burrs
from between the toes, poaching fish for the sled puller.
Our slippery progress over ice, muffled wind of speech.
In every world, this kind of touch,
singed by the aura of the sun's last. The shedding of clothes,
imprints of those creaturely feet on the dampened floor.
Fingers sliding into the fur, blind thumb on a curled pelt.
The raucous breath tinged dark with helpless sleep.

VIRUS

The first bars I recognized—
fever and sweats, the thorn-caged skull.
Then a desperate animal burrowed into my chest,
whose breathing had only moved
sickle-smooth through grass.

Twin bruises inside the knees
as if the clench of willpower were absolute to the bone.
It's that time when the body is most confiding,
most indoors and discrete,
its membranes swelling to a tympanic throb,
needing a certain humidity to linger and cool.

Body will be one day's statistic,
belonging to other people for an hour, pouting
with surprised cerise lips.
The rest will prove the loveliest of expositions.

Alone, I discover this breathing music
that is called pattern, tracing it through the steam
peeling paint from the raddled bathroom wall.
The little animal nuzzling my ribs,
its hungry sigh a diminished chord.

LONELIER PLANET

Purple martins, wings of mink,
skim low under austral thunderclouds.
They chatter about earth, its tender gravity,
how their Portuguese enchants the muse. Of gourds
hung out for the ancestral nests, caches of ivory eggs,
those mythic flights. Choiring the canopy,
mimicking the roil of the Amazon, they shine black
in the fertile heat. Birds of the Americas—
cyclone of wings that rush somewhere at night
before the snows, local music faint as human breath.
By all that's holy. And the river, with its mouth of stones.

HEALING, INTERROGATIVE

Rising today in a suit of steel, we interrogate our bones.
Usually it's the mind that complicates, enmeshes, wounds.
Femur and axe. Whistle up horses to carry us
from the battlefield. We bake garlic bulbs and honey them,
eat the bread of affliction. All that stirs stays within.
A neighbor leaves dried lavender posies at the door.
We cannot exchange air— six feet is the common depth.
A river of glands makes moan.
You won't forget? We are your signature and proof.

SUPERBIA

The baldness of winter pales.
Wolves slaver through these witchy months.

A new graft soon forgets its hard rupture;
the flesh marks New Year's when at last
we become redundant.

Our useless vigil in those isolated hours
while red juice stained fingertips, urine-tinted plasma
lolled in bags: low-hanging fruit.

Salvation is the alternate route. A friend's body buried
before tuberoses, evacuated robin's nests.
Thence the cold blooms.

What is stored on the plains of a perpetual off-season—
any other animal awakening to metaphor
would test the rind of a wild, original strain,
scatter its seeds.

In our palms, the shape of hothouse domesticity,
O pomegranate
lying so round, so perpetually intact.
With only the human apt to peel its skin.

AFTER NEW YEAR'S

Keening for the cold, Amundsen's dogs ate seal blubber,
howling and tearing each other's fur when they made no kill.
Then the dogs were kill, their toothy grins vanishing into
flames. I wonder if, loving them, I'd starve before eating
dog. My god has the head of a dog, I've lost more of them
than I want to count though I always held on, counting
breaths. The first time I lost a tooth, I strung it on a leather
thong, my flat dogtooth. Later I came to learn the flavor of a gap.
Come, he said—here is something good to eat. Seal?
No, no. We'll give up meat. When a fire burns through snow,
the camp is drenched. Melt drips onto the logs and skin
begins to freeze. If it is only a small fire to begin with, that is,
but you mustn't build a fire close to trees. The beating hearts
of pine, valves dripping resin. The restless bones.

INTERACTIONS

Listen: the drug I took with another drug
can be fatal though at this dose and under the tongue
probably acts more like a fine salt —
positive/negative chloride ions—
or the leaching of minerals from a garden
during heavy rains.
Delphiniums endure despite their preferences,
stalky, oft-blue perennial defying rot.
These chemical experiments,
a warm garden homeostatic with management
exists in a laboratory anterior to the phalanx of white coats.
No longer do they say It's probably nothing
when the hooded drinker stalls a nurse;
he ate his last meal yesterday. Or the day before.
From his desiccate flesh, delphinium eyes peer out
for an exit sign. Thousands have given up hounding him
for his foot on the first of the twelve steps.
When I say *him,* it's a male maybe seventy years old
whose coat turns inside out to leak clandestine ponds
of alcohol. Dogs follow around the Acropolis
for a breath of tainted meat.
We are all capable of such intricate self-harm.

NOTES TOWARDS A SELF

In quarantine the trees stand moated, absolute.
Worms and grubs crawl out for their loamy interval

to the flurry of starling and finch,
the pattern deceptively simple, a square of grass.

Punctuation shifts a key.
How to indicate the repossession of a self?
The flummery of leaves, beaten egg dashed from a nest,
is thin and bitter sustenance.

Flat hedges anchor the flimsy house.
How dangerous to cross the green boundary,
to learn that each is something if no particular thing:
the way of congregate fungi and sap that writhes and rises,
heaviness of the scarlet autumn-olive decadently ripening.

LINES ON KANDINSKY'S *COMPOSITION 8*

Vibrations in the soul, yes. Please note the discography
 the metronome the phonographic *I*
& all the rattling death marches. In the villages the crimson
swirling capes
 catch fire & fanfare chromatic, misted moons.
Include mountains & melodic signatures. Must live ably
within two bodies
 (something like a faun?) How we marched through
fog along the steppes

but is history a grid? If grid, define the lines via some
 auditory principle—
 each color has a vibration, an origin story
in the earth. A thread of river &
a dynamited bridge—is a project of recovery?

Suppose I leave you wondering about the pink triangle.
I refer you to the dawn's
 tender ice melt, the duple key of *F.*

GENERATION

I will tell you about creation, yours—
this is our pleasure, a way of feeding
the fragile volute heart.
A woman's thing, dreaming of a bird
flown into the mouth

maybe a crossbill overlapped by a hereditary quirk.
It does not study sex but starves for want
like any quickened being.

The waters were rising though we didn't hear
over flocks and gales, salt we threw over the shoulders,
soft swishing of a broom and in our palms
tender heads of roses, garnet drops of blood, that fairytale.

You grew by candles left virgin in the dark.
Under the skin, a seed swelled into lungs, brain,
a whole island apart.

With the pride of a generation,
I retell your birth, how you slid in a pulsing mass
and so blooded and queened me at once.
What sorrow to bask in a cold future,
pressing toward another kind of light.

ALTHOUGH, ETC.

Although it is still there
for all I know,
that garden of lost minds,
you are not there
so cannot smudge a tree
into a loose blackbird.
Imagine yourself
sleeping rough
by the holly bush,
skin prickled red
by the wild knives.

Why didn't I steal you
before doors were barred,
make a camp under the boughs?
One tree, concrete fed.
Limp leaves slit
by caterpillar jaws.
The metrics of your voice
stringing loose blackbirds—
why speak to you, knowing
you're too deep to hear?

FOR THE DARK

Dusk that is woven of sighs and a bomb of sparrows
shooting over grass: a mild explosion before thunder breaks.

For us the sighs, the birds, the thunder
spin a little drama out of air

while in intervals of eastern waves, a minute wipes out
even the shadows of fisher hawks. We glimpse the water,
hear cries tamped beneath mud in a cellphone video.

A group of women scream and disappear,
breath mingled with the wind.
So close to the edge, does the documentarian survive?

On the beaches they say lies anything,
everything touching the human sphere.
Imagine tangled skeins of clothes, smashed festival lights,
a wooden pipe sluiced of ash.

Corpses of the swimmers carried from wreckage
by sea or living hands.

And as the rain comes down 9,000 miles away,
we think of those frozen figures of Pompeii going about
in their easy ignorance, and relic ourselves
with open mouths upon this frieze.

THE TREE GROWS ELECTRIC

Neighbors electrocute the tree with Xmas lights
when the ground is milk. We don't know why buds
like antlers under snow are not good enough;
suppose the tree shrugs off tiny burns
and stills the sap to resist. Say it's a pine
that survived house fires, lightning's proverbs, torch,
can withstand even this disgrace. Maybe we
are next-door's maple overlooking the difference
between deciduous and evergreen,
cheering for an outage, windows gone black.
Maybe tool-makers and artisans,
builders of ships, carvers of bowls, love wood.
Not this way, last year's acreage cleared of scrub,
just the tallest spared. We doubt the tree
is conscious of eyes while mustering rootlets
in the damp. Something, though,
recalls the need for light in the year's nadir.

MEAT

Turkey vultures are back again, wheeling like drunk cyclists.
Are they constant or a jealous intermittency, whiffing flesh,
a high-smelling cache of bats, of seldom porcupines.
Few Augusts left, and I've escaped most harm—
an unfriendly thistle drawing blood, a squashed baby toad.
Things netted, dried, date back to the brash summers here,
long explores and the shimmering residue of ghost crabs.
Gull girls have married into the blue, leaving a faint trail
more durable than meat decaying whitely in the sun,
the prey of Cape buzzards and persisting fat flies.
The dog clings to my shadow, noses scrubby pine.
At the old cemetery, there's a smell of sanctity. Though
maybe only mushroom rot or the draggled, gem-like moss.

HUMMINGBIRD AFTERNOON

In low resolution, the hummingbird seems
to pluck at salvia with childlike greed—

rain wraps the house in inquietude,
the joists sweat. How frail bones skirmish and thrash.

The drone shatters, but what of the hummingbird?

Nothing safe's
from our imago.

It dies in the salvia: a chromatic sigh.
No intelligence to gather. And no hopeful mate

zigzagging and plummeting
in a wind tunnel of tail feathers, that piquant aviator

diving for love
with a wanton whistle.

Piccolissimo, quarter-sized flier,
comes trustingly to your hand.

You tweeze out metal splinters
to resurrect the jeweled machine.

The beak unhinges pitifully. You feed it oil
from a dropper. Teach it to sing.

NATURAL CAUSES

The sea creeps, a bloodstone tide,
a forest of kelp jells in clots. Viridian and spume.
Long chains of weed and fishbone drape the rocks
in widow's weeds; the sea is first murderer.
Prayers to Stella Maris wash up laggardly.
Terrible allure of high tide at night—
how the moon drags this world to its own sphere.
Sailors push their boats out past the spit,
break the oceanic membrane.
Poseidon's trident dissects star from star,
beard tangling anemone and crab.

ELDERBERRY

Sweet, pleasant elderberry—
blue-black fruit clustering, ragged bell of the old field
from the ancient pharmacy. Before there was a spoon
a blistered tongue licked the palm, lips grew stained.
Taste the tooth-jarring top, musky under-notes,
pour it on troubled waters, Gulf fires and bombsites.
Fall and break, get stitched in dawn's corridor,
ivory of cheek and jaw, mended china doll lie abed
and do not touch the lively, making scars.
Study shapes of breath, how glands branch from a trunk,
don't mourn overmuch. Even the elderberry's
not immune.

FED UP

To stop eating one thing you can eat another thing.
It might be chocolate spiked with Bolivian salt
chased by a hunk of Edam cheese.
The tongue hunts sweets with fats,
or maybe the hippocampus,
the insula, not the wagging limb of the mouth
that is liable to monologues
your lover has no wish to hear, preferring a silent meal;
it laps the pledge of allegiance, so vast a promise
that the very soul quails before it,
bids the tongue cease clapping in its bell.
Eating thus quickened by incubi of desire and remorse,
each bite carved from the odd remembrance
sprouting verdigris, you find pen pals in the desert
and pledge them shrink-wrapped delicacies:
dried figs, caramels, roasted nuts and Kools.
Whatever you have done— crossed state lines,
committed forgery or theft—this hunger doesn't quit.
Shaped in the dysmorphic image, what a bloated Shelob,
craving terrible pairings. Offal with sawdust,
shellfish from condemned waters, a whiff of oily brine.
The wax from melted candles, spores of *P. infestans*.

AGNOSTIC PRAYER

Damp curl licked between the un-sprung polls,
here is slick chain,
calf-jack, ceremonial of the temple barn.
I learned the hungry pull of want.

Through exodus, the bones of legend
reassemble themselves to shine
as a white bull on the Phoenician shores,
while I could only thumb a harp of grass.

Pray all birth pangs be translated into warmth and thrive.
My teeth refuse to close on meat.
A tilled field loosens its flock, enough and enough.

On Sunday a man is pounding nails into a beam:
a constant urge to pray to flashing hooves, a homing heat.

SOLVE FOR *X*

A dissected lemon starred with currants
lolls between lovers

when miners split the earth for gold
by algorithm say the 8-day lapse between fever and chills

the fecund female with her egg basket full the velvety bat
how we've starved our borders—yet permeable

a ripe disease how spring has painted us into small corners

this threading pulse
anchored to the same desires serpentine

currants in citrus and puckered lips

cannot use the thumb for a pulse
child that's got its own

a day clothed in marvel (virtual lilies in smoke)

those floating morgues
the sea the sea the Flying Dutchman

born into the age of the cure,
shall we now belong also to history—

on land I hide like the stubborn impulse of a bud

I ALMOST LOVED THIS

In a more acquisitive time, a chipped jar
from a secondhand shop thrust a beak my way
and at once, I was almost ready to love.
It posed as a receptacle for a Chinese yellow rose
and then again as a spittoon. It made as if to smell
of honey and jam, flirting its fluted lip.
I thumbed a kiss, round and round,
this womanish vessel open, up for anything,
across the world earth cracked like an old face
and hundreds plummeted down. For these,
no case of adjective, only the devouring verb.

IMMUNITY

All contour and desire.
To which is added, the warm-blooded vector's guilt.

This strange persistence: apoplexy of poppy bloom.

So hard to parse sirens cleaving a perfect blue-gold,
trees yet heavy with faded leaves dappling planes of flesh.

Up north, the cold clamps down on towers, fields,
muzzles of chrysanthemums that smell of dog and earth.

Your body my asylum. Only winter as wide and clean.

THE FIRS AT THE LAKE COTTAGE

In age, their placement perfect
as that of constellations in a rural sky,
they circle the stucco walls.
I recall each window facing south,
impossible logistics of a child's dream.
If waxwings lit the branches of the firs,
they must have nested peacefully,
so densely woven the piney sleeves.
Roots milk the piled bones in the earth
a handful of years after the war.
Here were the scrawls of a fevered child,
bonfire of quilt, a wishbone buried deep.
All that was had always been so—
small toads camouflaged as stones,
sun licking at the farther shore.
Oh no, you said, the firs aren't so old;
our father wearing mufti planted them,
waiting to be shipped out overseas
and finding some relief on the ground.
Who wakes these days in the house
might privilege willow or black ash,
or camp where deer and moose still feed,
be strong enough to dig up flagstones,
fix holes in crumbling masonry.
Or maybe he'll leave things as they are,
spare the revenants in the trees.

AUTUMN

Which curvatures still shine as night begins its master class
in sightlessness? Flickers of wind escape north, casting
the trunk in icy profile, while winter is weeks off.
This darkness sharpens another sense, stiffens desire—
mercy corrects the blind glance, motion corrects it, flit and
thrust pick out networks of sharp twigs, extremities of sap.
Wings enfolded in paper planes. Dusk is busier than what—
a skein of swallowed words, untangling of the final warp.
The camel bridge is numb to my foot. I have burials to attend,
alleys of sullen cherry and lilac where grass was.
On this calendar, each day sainted with peculiar tints,
look for the sign of a bird and crumbs of casual tenderness.
Someone with a notebook and fingers of charcoal
turns my way expectantly, pointing
where a shadowy plume's fallen into his net.
He has waited while the fleshly warmth runs down
and lamps crisscrossing the park blush with artifice.
I have no instinct left for the hunt but this emptiness
to learn, a hollow whistling, a pocketful of stealth.
The little-seeming bird and tree resume their intimacy.
No other thing pretends to feel the dark.

POLITICS

Where have I left the least of these things, broken pots
in which nothing bloomed, half-sung songs with words
drained away? I might have known more depth unlike
the stream that overflowed its bounds, mocking
providence. Death ignites the country; air smells of char.
I wish peace to an old neighbor who feeds foxes,
flicking deer ticks from a hem, mouth a bitter row.
The clangor of that lane succumbs to a fall
of yellow leaves, graves she showed me,
last year's fragile bones, sunk in deeper profundity.
States with internecine wars, statues without heads:
I have not stopped to visit twice where humans live.
If we looked beneath soil's skin, would we find
whole villages of sightless eyes, the lacrimal bone
small as a fingernail. In my neighbor's field,
five bits of meteor fell from the sky,
that hard stuff of the universe.

THE PAUSE

Now the rain doomed to repeat,
called sometimes by the plural, more often alone.
Now the blued bed damp with sweat
seeping through the body's motile structures
is stained with the contrast dye of mumbled speech.
Breath is a coded message too,
the tremor of cotton sheets an ampersand.

Is this gray skin the residue of clouded dreams?
A zombie afternoon, another long-drawn pause
through which damage severs us.
More than bread, your sleep
feels sacred to me, and that crescent of light,
a wink birthed of reflex, celestial.

The trope of night cereus is too precious,
but wild onions sprout along train tracks.
Stupid with humidity, flies from the butcher shop
find a way to compound the anomie.
Today's dusk will be indistinguishable from dawn,
says the radio. Yes, there are still radios
and gunshots halving the intervals between breaths.

STASIS

Wing with its stippled stain—
earthward, plaids of wheaten green,
clouds tumbling to roseate vagary;

newness spilling onto raw asphalt
beyond the plane's high hum
echoed in the taut rib space.

Arrival smelled metallic as ozone,
lure of earth's comforts, the wrapped fruit, baguette,
taxies glinting in papery rain

where that scimitar called longing
cleaves resistless flesh. Were you stunned
at arriving wingless, unshelled;

was equipoise of heel and toe,
the crush, breath, perfume of passing streets,
were these other than enough?

COLD SPRING BY TRAIN

Workshops and cafes are shut,
geese scumbling dry fields.
Breakneck Ridge is broken teeth;
Cold Spring's hammered by wind
while the day snails behind wish.
In this low stretch of sky,
the inner planets seem very near
and pallid in milk-light, the Great Bear.
At every station I've wanted to run,
den under the statue of the old soldier,
taste local honey by a fever spoon.
With every mile, I've jettisoned
some strand of hair or cell of skin.
A pile of rags: an incurious fox
crosses the tracks with a bloody mouth.
Cold Spring without its human guise,
a wandering herd of stone.
Inhabitants must be somewhere
beyond their frowsy artifacts
hunching by coal stoves.
Outhouses, enamel basins,
spiny gables, Depression glass.
The foundry dark and quiet as —
but don't say it, even you don't
want to hear that word.
I wonder how many dreams molt
where a papery slice of lady cake
is coffined in with string.
Ever in pursuit of other lives —
those muddy boots on a porch,

sleeping frogs in Margaret's Stream,
a woman hammering chains from gold,
her neck in the soft light bared.

BEDDING DOWN

Night rangers are bedding down the green.
Fingers tie up sagging fence, pikes of sentry gingko,
as a cool wash of twilight overspreads malachite and lime.

Time to seed the lawn where you foraged ahead of sleep:
jasmine and dark iris, sterilized in winter's forfeiture
while ants crawl twining vines. A hoarding instinct for lack.

Dogs with unknown names, rachitic dogs with cataracts—
can we not ask the ground to push up one last stalk,
a pristine bone, to let us sprinkle ash. Out of burial,
a rough new season comes.

In sovereignty over small acreage, rusted trucks roll on
as clouds surge perpetually east-west
and counterclockwise planets oppose shadows
that droop, left to lag with spider webs.

Past ovals of barred fields to the hard edges of town
a mass flows thick against traffic.
Many mouths struggle to equal one; a woman's blouse
swells with a high-carried, orotund metaphor.

IMMORTALITY

From the Karman chair wheeled to lunch,
you press the bearded iris on me. The therapy dog
is well-conformed, keen-nosed yet biddable.
To walk to the creek, impossible, impossible
the cellar stairs, mounds of laundry, dust mice,
spiral notebooks, the pointless lone ice skate.
Your still-deft hands grasp a glass of tea.
I'm here, as if I'll always be
stronger than that justifiable rage
fed from a dish of cracked pink salt.
The bearded iris goes by Immortality.

Bred to charm the meanest eye—
why iris, in these indrawn days? It clings
like the ancient chestnut tree menacing
the low garage, an incestuous tree (but the iris,
tethered to its little patch of soil, sword-shaped,
anthers flirting to re-bloom). Abashed sun
filters through chestnut leaves, loquacious roots
banked stubbornly. A skunk slinks past the drains.
Your nurse rolls down her stockings, texts,
smokes an unfiltered cigarette.
Doesn't everything grow rich,
the burrs that cling to the dog's rough fur
indentured for dispersal, dissuading deer,
yet untouched by blight. The lustrous lemon air.

ABOUT THE AUTHOR

CAROL ALEXANDER's previous books are *Environments* (Dos Madres Press), *Habitat Lost* (Cave Moon Press) and *Bridal Veil Falls* (Flutter Press). Her work has appeared in a variety of literary journals. Alexander is a writer and editor in the field of educational publishing and has authored fiction and nonfiction books for young readers. She lives with her family in New York City.

Other books by Carol Alexander
published by Dos Madres Press

Environments (2018)

For the full Dos Madres Press catalog:
www.dosmadres.com